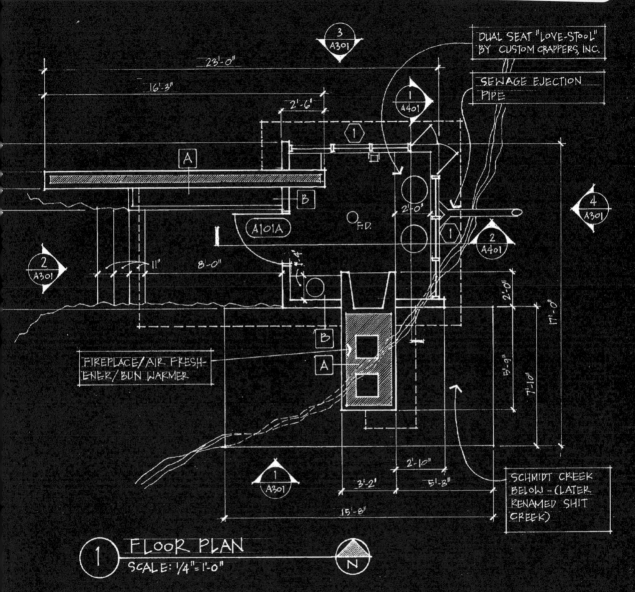

DUAL SEAT "LOVE-STOOL"
BY CUSTOM CRAPPERS, INC.

SEWAGE EJECTION
PIPE

23'-0"

16'-3"

2'-6"

3
A301

1
A401

4
A301

1

A

B

A101A

2'-0"

F.D.

1

2
A401

2
A301

11"

8'-0"

1'-4"

2'-0"

17'-0"

B

5'-9"

A

7'-10"

FIREPLACE/AIR FRESH-
ENER/BUN WARMER

2'-10"

SCHMIDT CREEK
BELOW - (LATER
RENAMED SHIT
CREEK)

1
A301

3'-2"

5'-8"

15'-8"

1 FLOOR PLAN
SCALE: 1/4" = 1'-0"

N

OUTHOUSES

BY FAMOUS ARCHITECTS

TEXT AND RENDERINGS BY STEVE SCHAECHER
PREFACE BY I. P. DALEY

Pomegranate

SAN FRANCISCO

Published by
Pomegranate Communications, Inc.
Box 6099, Rohnert Park, CA 94927
www.pomegranate.com

Pomegranate Europe Ltd.
Fullbridge House, Fullbridge
Maldon, Essex CM9 4LE, England

Pomegranate Catalog No. A533

Library of Congress Cataloging-in-Publication Data
Schaecher, Steve, 1967–
 Outhouses by famous architects / Steve Schaecher.
 p. cm.
 Includes bibliographical references.
 ISBN 0-7649-1260-7 (hb)
 1. Architecture—History—Humor. 2. Outhouses—Caricatures and cartoons.
 3. American wit and humor. I. Title.

 NA2599 .S33 2000
 728'.9—dc21 99-057034

Cover and interior design by Monroe Street Studios, Santa Rosa, California

Printed in China

09 08 07 06 05 04 03 02 01 00 10 9 8 7 6 5 4 3 2 1

THE DRUIDS

CIRCA 2000 B.C.

The Druids are thought to be the society responsible for the construction of Stonehenge. Documentation is sketchy, but it is believed that they were loosely organized in a number of tribes, each with its own territory. Their religion was centered around the stars, celestial motions, and the essential nature of things.

Stonehenge was just one of the ceremonial worship areas the Druids constructed. Their achievements were extraordinary. The blue stones used in the construction of Stonehenge were transported nearly one hundred forty miles and lifted into a mortice-and-tenon configuration. The plan was circular, and oriented to specific juxtapositions of the earth, the sun, and the stars.

Thronehenge, another example of these monolithic worship places, reveals a shift in belief for the Druids. The participatory function of the "throne" provides a connection between the user and the heavens. As the sun rises at the summer solstice, it is centered perfectly over the throne, possibly indicating a divine act. The stones here are equally remarkable as those at Stonehenge. They are brown in color and are believed to be of animal origin.

OUTHOUSES
BY FAMOUS ARCHITECTS

CONTENTS

PREFACE

The history of civilization, and certainly the history of architecture, demonstrates beyond argument that the human imagination must always have room in which to unburden itself. But that room need not necessarily be a big one.

As Steve Schaecher's marvelous volume so sensitively shows, the visceral, insistent mandate to create small spaces of vast importance has persisted from the High Colonicism of the Greeks down to the spartan yet evocative Eliminatism of this last decade. What is fascinating here is humankind's historic preoccupation with mass, complemented by an equally urgent yearning for relief.

The liberating vision of an Odor Dame Cathedral (or of its philosophical sister, Phartres Cathedral) does not impose, but rather releases—explosively annulling all tensions and static boundaries in a powerful manifestation of individuality.

Where this monumental outburst of will erupts in cosmic scale, it stands in diametric opposition to the fluidity of the organic forms sought by, say, Schütte-Lihotzky's Frankfurter Nebengebäude and other Modernist creations. Here, turgid "plasticity" is forsworn—transcended, rather—for a quality that approaches the gaseous.

No less ambitious, if far less bombastic, are the structures whose creators have concerned themselves with humble comfort. In these, our corporeal selves are made welcome and relieved of quotidian pressures even as our inner energies are released into the empyrean. In their modest way, these designers have sought nothing less than the transformation of society, a transformation that can emerge only from the deepest reaches of the self. Thus modernism accommodates individualism, and a longstanding breach is healed.

Enough of theory. Onward, reader, to the peristaltic wonders revealed in this fine and highly necessary book.

—I. P. Daley
Roscoe College, Oxford

STEVE SCHAECHER

BORN 1967, COLUMBUS, INDIANA

Steve Schaecher studied architecture at Ball State University. Currently a registered architect working in Indianapolis, Indiana, he moonlights as a cartoonist. His strip *Oblique View,* focusing on humor in architecture, was published by the *AIArchitect* newspaper.

Schaecher's warped view of architecture reminds us to enjoy life and look for reasons to laugh. Sure it's a serious profession but lighten up a little. He resides in Speedway, Indiana, with his wife, Susie, and son, Nathan.

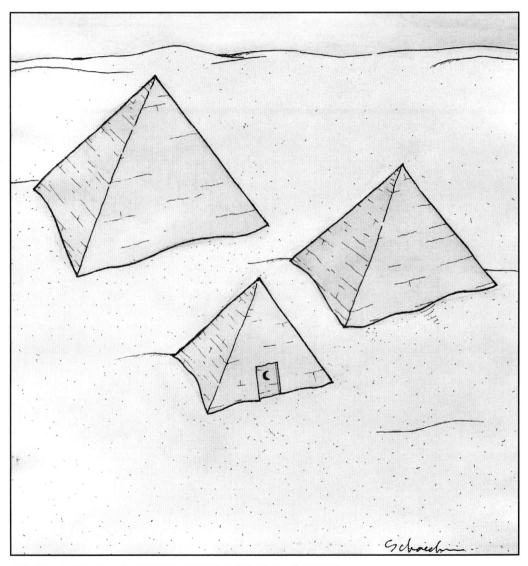

PYRAMID OF TOOTANDDROPIN

THE EGYPTIANS

CIRCA 3200 B.C.–1085 B.C.

THE EGYPTIANS WERE AMONG THE FIRST CULTURES TO RECORD THEIR CIVILIZATION. GOVERNED BY PHARAOHS (MONARCHS THOUGHT TO BE DIVINE) AND CENTERED AROUND A RELIGION FOCUSED ON THE RITUALS OF LIFE, DEATH, AND THE AFTERLIFE, EGYPTIAN SOCIETY WAS LARGELY AGRARIAN, UTILIZING SLAVE LABOR. THE NILE RIVER WAS ESSENTIAL TO THIS SOCIETY, PROVIDING TRANSPORTATION OF ITS GOODS AND A VAST, FERTILE VALLEY TO SUPPORT ITS FARMS.

THE EGYPTIANS' ARCHITECTURE SOUGHT TO MATCH THEIR MAGNIFICENT SURROUNDINGS—THE NILE, THE MOUNTAINS, THE DESERT. THE BASIC FUNCTION OF THEIR MAJOR BUILDINGS WAS TO HONOR THEIR RELIGIOUS BELIEFS. THE PYRAMIDS WERE PRIMARILY ERECTED AS TOMBS FOR PHARAOHS WHO HAD JOINED THE SUN GOD, AMON-RA. THE CONSTRUCTION OF THE PYRAMIDS AND THEIR SURVIVAL OVER TIME IS A TRIBUTE TO THE EXCELLENCE OF EGYPTIAN TECHNOLOGY.

THE PYRAMID OF TOOTANDDROPIN (NAMED FOR THE PHARAOH WHO WAS THERE MOST OFTEN) WAS CONSTRUCTED FOR A SPECIAL PURPOSE: AS AN OUTHOUSE. THE EGYPTIANS' RELIGIOUS BELIEFS CENTERED NOT JUST AROUND THE ASCENT OF THE BODY TO THE AFTERLIFE, BUT ALSO AROUND THE DESCENT OF BODILY PRODUCTS. EXPERTS HAVE CONCLUDED THAT THE CONCENTRATION OF HIEROGLYPHICS NEAR THE STOOL IS THE FIRST APPEARANCE OF BATHROOM GRAFFITI.

OUTHOUSES BY FAMOUS ARCHITECTS

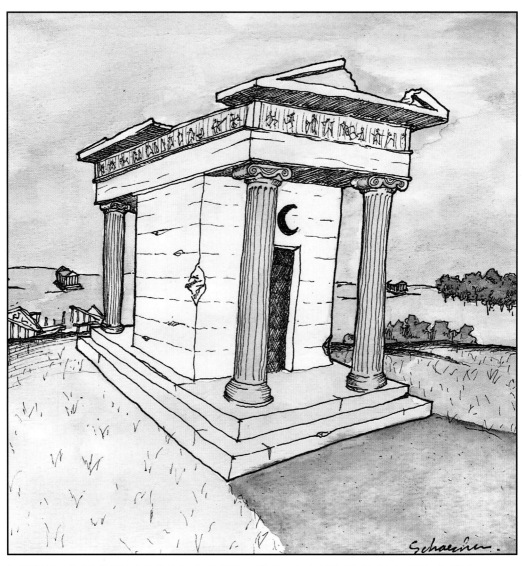

TEMPLE TO RALPHUS, GOD OF PORCELAIN

THE GREEKS

CIRCA EIGHTH CENTURY B.C.—FOURTH CENTURY B.C.

THE GREEK CIVILIZATION WAS ONE OF CULTURAL REFINEMENT. ITS UNITS OF GOVERNANCE WERE CITY-STATES, RATHER THAN A KINGDOM. TWO DISTINCT PEOPLES FORMED THE GREEKS—THE DORIANS, A MILITANT, HIGHLY DISCIPLINED SOCIETY, AND THE IONIANS, A MERCANTILE SOCIETY. DESPITE THEIR DIFFERENCES, THE COMBINED FACTIONS FLOURISHED AS A SINGLE CULTURE. THE GREEKS WERE ASTUTELY PHILOSOPHICAL AND DEEPLY RELIGIOUS, DEVELOPING A MYTHOLOGY THAT IS STILL REMARKABLE FOR ITS BEAUTY AND PROFUNDITY.

GREEK ARCHITECTURE SOUGHT TO EXPRESS THE ADVANCES OF GREEK CULTURE AND TO PRAISE GREEK DEITIES. THE MOST NOTABLE FORMS WERE THE TEMPLES. THEY WERE CONSTRUCTED NOT AS PLACES OF WORSHIP, BUT AS SYMBOLIC DWELLINGS OF GODS AND GODDESSES. THE REFINEMENT OF ORDER AND PROPORTION WAS ALWAYS PREVALENT IN THEIR WORK.

THE TEMPLE TO RALPHUS IS AN EXAMPLE OF GREEK REFINEMENT. RALPHUS WAS THE GOD OF PORCELAIN, A WASHABLE, WATERTIGHT MATERIAL THE GREEKS DISCOVERED IN TRADING WITH MONGOLS. THIS TEMPLE WAS DESIGNED TO ALLOW ONE VISITOR AT A TIME. VISITORS WERE COMPELLED TO KNEEL BEFORE THE STATUE OF RALPHUS INSIDE AND EMPTY THEIR SOULS.

OUTHOUSES BY FAMOUS ARCHITECTS

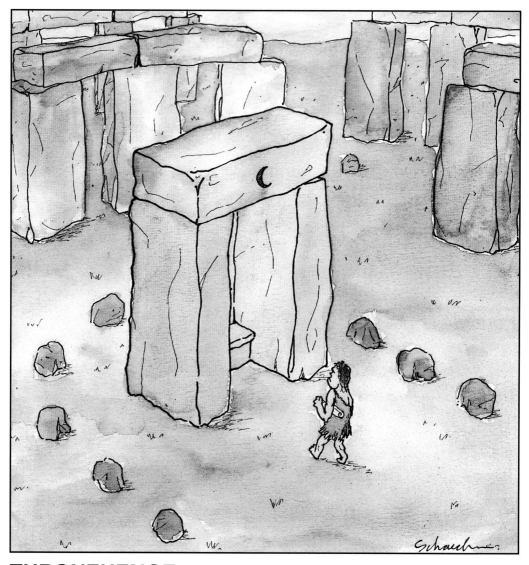

THRONEHENGE

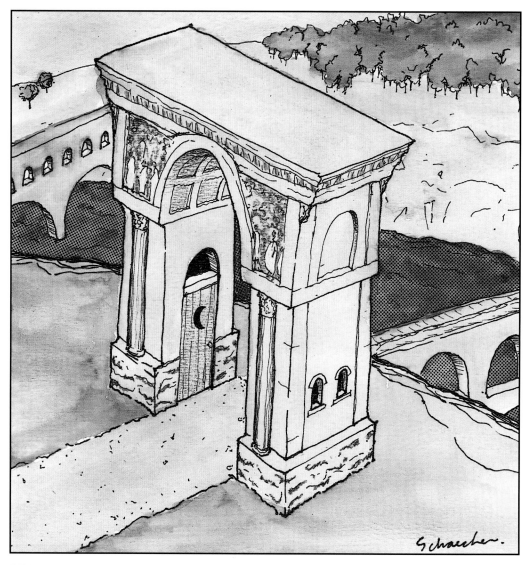

**THE TRIUMPHANT COMMODE OR
THE ARCH OF BUSINESS**

THE ROMANS

CIRCA EIGHTH CENTURY B.C.—FOURTH CENTURY A.D.

THE ROMAN EMPIRE COVERED AN AREA FROM THE TIBER TO THE NILE TO THE THAMES AND BEYOND, AND LASTED MORE THAN A THOUSAND YEARS. THE ROMANS' CULTURE WAS AS SOPHISTICATED AS THAT OF THEIR GREEK PREDECESSORS. THEIR SOCIETY WAS DEDICATED TO DUTY, FAMILY, THE GODS, AND THE STATE. WITH REMARKABLE ACHIEVEMENTS SUCH AS ROADS AND AQUEDUCTS, CITIES WITHIN THE EMPIRE WERE CONNECTED, ORDER WAS KEPT, AND COMMERCE FLOURISHED.

GREEK INFLUENCE CAN BE FOUND IN ROMAN CULTURE AND ARCHITECTURE. THE PROPORTIONS AND MONUMENTALITY OF THEIR BUILDINGS ARE NOTICABLY SIMILAR TO THOSE OF THE GREEKS. HOWEVER, THE ROMANS BROUGHT THEIR OWN ARTISTIC SENSIBILITIES TO DESIGN, USING NEW MATERIALS AND TECHNIQUES TO DEVELOP THEIR OWN STYLE. THE MOST NOTABLE CONSTRUCTION ACHIEVEMENTS FOR THE ROMANS WERE THE USE OF THE ARCH AND THE VAULT. THE ARCH BECAME THE STRUCTURAL AND ARCHITECTURAL ELEMENT THAT IDENTIFIED A ROMAN BUILDING.

TO COMMEMORATE ROMAN CONQUESTS, ARCHES WERE CONSTRUCTED THROUGHOUT THE CITY. THE ARCH OF BUSINESS WAS CONSTRUCTED BY AUGUSTUS, TO HONOR THE CONQUEST OF THE SANITARY NEEDS OF THE PEOPLE. ALSO KNOWN AS THE TRIUMPHANT COMMODE, IT WAS THE FIRST ARCH LINKED DIRECTLY TO A SEWAGE AQUEDUCT.

OUTHOUSES BY FAMOUS ARCHITECTS

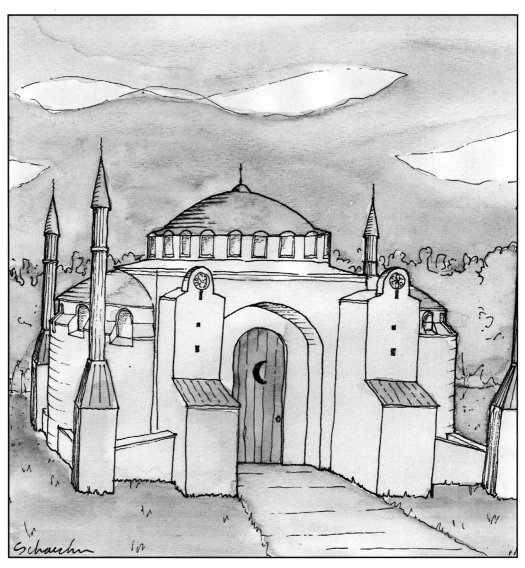

THE CACA SOPHIA

ANTHEMIUS AND ISODORUS

BORN 500-SOMETHING, ASIA MINOR
DIED LATER, SOMEWHERE IN ASIA

ANTHEMIUS WAS BORN IN TRALLES (TURKEY) AND IS THOUGHT TO
HAVE STUDIED IN ALEXANDRIA. HE WAS A SCIENTIST AND THEORETI-
CIAN, AS WELL AS AN AUTHOR OF A BOOK ON CONICAL SECTIONS AND
VAULTING. ISODORUS WAS BORN IN MILETUS (TURKEY) AND IS
BELIEVED TO HAVE STUDIED IN CONSTANTINOPLE. HE WAS AN ENGI-
NEER AND A PROFESSOR OF PHYSICS.

IT IS BELIEVED THAT THE TWO OF THEM TEAMED UP ON SEVERAL
PROJECTS—ANTEMIUS SERVING AS A PROJECT MANAGER AND
ISODORUS WORKING AS THE ARCHITECT-ENGINEER. THEIR GRANDEST
ACCOMPLISHMENT WAS THE DESIGN OF THE HAGIA SOPHIA. THIS PIECE
WAS THE KEYSTONE OF THE EMPEROR JUSTINIAN'S BUILDING CAM-
PAIGN. COMPLETED IN FIVE YEARS, THE BUILDING IS REMARKABLE FOR
ITS EXPANSE OF SPACE AND PRECARIOUS STRUCTURE, FEATURING A
SERIES OF DOMES PLACED ON PENDENTIVES AND ARCHES.

TO TEST THEIR THEORIES, ANTHEMIUS AND ISODORUS CONSTRUCTED
THE CACA SOPHIA IN ANTHEMIUS'S BACK YARD AS A MOCK-UP. THE
TEAM DEVELOPED THEIR SERIES OF DOMES WITH REMARKABLE PRECI-
SION AND SPEED: ANTHEMIUS'S MODESTY PROMPTED AN ACCELERATED
SCHEDULE TO CONCEAL HIS "THINK TANK." AESTHETICALLY, THE CACA
SOPHIA HAD PRECISELY THE SPELLBINDING EFFECT DESIRED BY
JUSTINIAN. USERS OF THE FACILITY WERE OBSERVED TO STAY INSIDE
FOR HOURS.

REVISIONS | BY

**OUTHOUSES
BY FAMOUS ARCHITECTS**

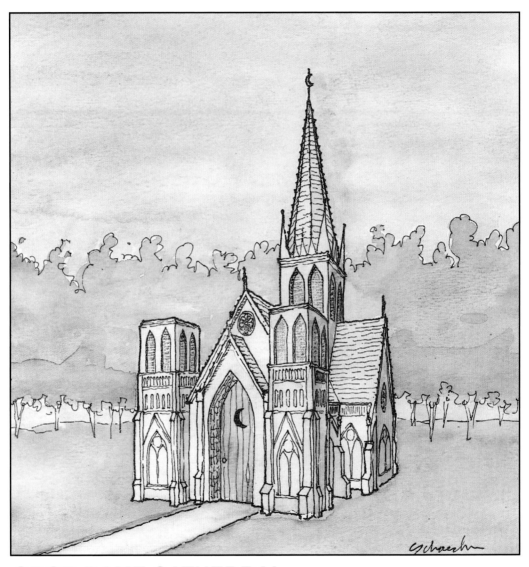

ODOR DAME CATHEDRAL

GOTHIC

CIRCA 1100 A.D.-1400 A.D.

After the fall of the Roman Empire, the culture and art of the Western world had fallen into a lightless void until the Renaissance. At least this is what the Renaissance thinkers thought. The tribes that invaded the Empire—the Goths—ruined the ancient arts and substituted their own inferior culture. The term "Gothic" then became associated with this era and was cast in the gloomiest possible light by the Renaissance thinkers.

Gothic architecture contradicts the Renaissance attitude. It achieves art and cultural achievement dynamically. It can be broken down by three emphases—the structural, the visual, and the symbolic. Structurally, the style reduced the mass of the building, using a skeleton for support. Visually, the lightness of the structure and the role of light lend elegance to the buildings' mass. Symbolically, these buildings were built to magnificent heights in an effort to reach to the heavens. The cathedral became an image of the Divine City and a vision for salvation.

The Odor Dame Cathedral is a minor example of Gothic architecture. It utilizes the common elements of the style: flying buttresses, Gothic arches, and rosette windows. The intent of this design was to create a personal cathedral that would elevate the outhouse experience to new heights. It succeeds in its efforts, but is considered too extravagant for its function.

OUTHOUSES BY FAMOUS ARCHITECTS

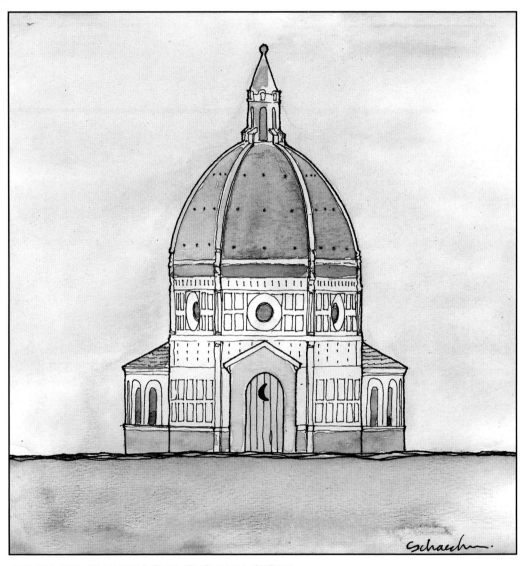

THE FLORENCE COMPOST

FILLIPPO BRUNELLESCHI

BORN 1377, FLORENCE
DIED 1446, FLORENCE

BRUNELLESCHI STARTED HIS CAREER AS A SCULPTOR AND A GOLD-
SMITH. HE ACHIEVED MASTER STATUS IN 1404 AND CONTINUED TO
SCULPT FOR MOST OF HIS LIFE. HE TRAVELED TO ROME TO STUDY
ROMAN SCULPTURE AND THE TECHNIQUES OF ROMAN ARCHITECTURE.

BRUNELLESCHI BEGAN TO APPLY WHAT HE HAD LEARNED TO HIS
WORK. A GENIUS IN ENGINEERING, MATHEMATICS, AND OTHER TECHNO-
LOGICAL PURSUITS, HE WAS ONE OF THE FIRST ARCHITECTS TO UTILIZE
MATHEMATICAL PERSPECTIVES TO REFINE SPACE AND DESIGN PRINCI-
PLES. HIS WORKS ARE PRIMARILY LOCATED IN FLORENCE; THEY
CHANGED THE CITY'S APPEARANCE AND SET THE TONE FOR THE ARCHI-
TECTURE OF THE RENAISSANCE.

THE FLORENCE CATHEDRAL IS BRUNELLESCHI'S MOST NOTABLE
WORK. THE CATHEDRAL'S DOME WAS A MONUMENTAL UNDERTAKING
AND PROVIDES AN AMAZING EXAMPLE OF TECHNICAL GENIUS.
BRUNELLESCHI SOUGHT TO REPRODUCE HIS MASTERPIECE WITH HIS
FLORENCE COMPOST. THE REFINEMENT OF THE ARTS WAS UNDOUBT-
EDLY IN HIS MIND WITH THIS PIECE. THE PROPORTIONS OF THE DESIGN
AND THE ENGINEERING REQUIRED FOR THE DOME TRULY INSPIRE USERS
TO PERFORM THEIR BEST. THE RECYCLABLE NATURE OF THE COMPOST
REVEALS THAT BRUNELLESCHI ALSO HAD ENVIRONMENTAL SUSTAIN-
ABILITY ON HIS MIND.

OUTHOUSES
BY FAMOUS ARCHITECTS

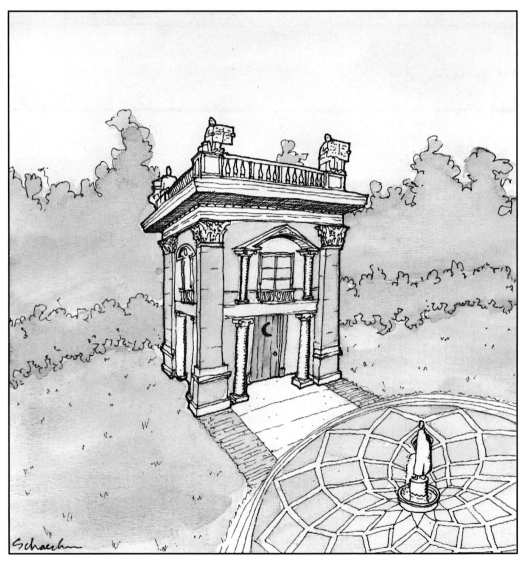

PIAZZA DELL' CAMPANDDUMPO

MICHELANGELO

BORN 1475, CAPRESE
DIED 1564, ROME

MICHELANGELO BUONAROTTI WAS FORTY YEARS OLD WHEN HE BEGAN PRACTICING ARCHITECTURE. HIS SCULPTURES AND PAINTINGS ESTABLISHED HIM AS THE MASTER OF THE HIGH RENAISSANCE PERIOD. HIS CREATIVITY AND INFLUENCE WERE INFINITE, AND CHANGED THE COURSE OF ART. IN ARCHITECTURE HE WAS EQUALLY MASTERFUL, INCORPORATING HIS SCULPTURAL EXPERTISE INTO THE DETAILING OF HIS WORKS. THIS SCULPTURAL MANIPULATION OF BUILDING COMPONENTS INITIATED THE BAROQUE STYLE.

MICHELANGELO'S ARCHITECTURE ALWAYS CONCENTRATED ON THE COMPOSITION OF THE PIECE, MUCH LIKE A PIECE OF SCULPTURE. HE REJECTED THE RESTRICTIONS OF CLASSICAL ARCHITECTURE AND DEMONSTRATED HOW THE STYLE COULD BE STRETCHED WITHOUT DESTROYING IT. HE IS CONSIDERED ONE OF THE KEY INNOVATORS OF THE SIXTEENTH CENTURY.

HIS PIAZZA DELL' CAMPANDDUMPO DEMONSTRATES HIS CONTROL OVER THE DESIGN. THE PROJECT DRAMATICALLY INTEGRATES THE EXTERIOR WITH THE OUTHOUSE USING A RATIONALLY ORGANIZED AND ANIMATED DESIGN, INCLUDING A PLAZA. THE SCULPTURAL RELIEF OF THE FACADE AND THE CORNICE ELEMENTS EXPRESS MICHELANGELO'S APPRECIATION FOR THIS FACILITY AND ITS USE. HE FELT THIS HOUSE WAS THE PLACE WHERE HE CREATED HIS BEST ARTWORK.

OUTHOUSES BY FAMOUS ARCHITECTS

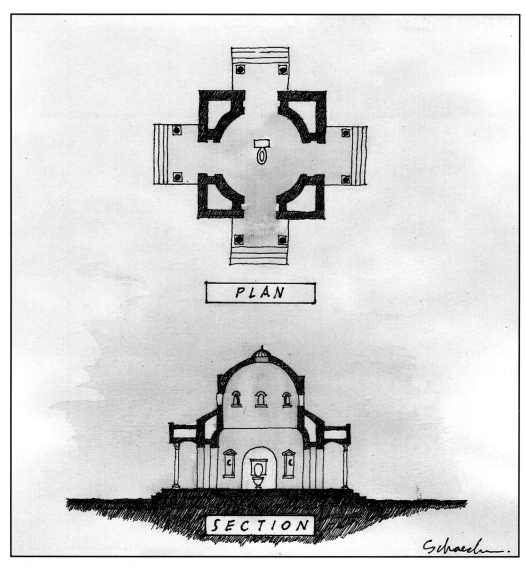

PLAN

SECTION

VILLA CRAPPERIA

ANDREA PALLADIO

BORN 1508, PADUA
DIED 1580, ROME

PALLADIO WAS A STONE MASON UNTIL HE MET TRISSINO, A POET, PHILOSOPHER, AND CONNOISSEUR OF THE ARTS. TRISSINO SAW SPECIAL ARTISTIC AND INTELLECTUAL GIFTS IN PALLADIO AND BROUGHT HIM TO ROME TO BECOME EDUCATED IN THE CULTURAL ARTS. HERE HE SKETCHED AND STUDIED ANCIENT ARCHITECTURE. INSPIRED BY VITRUVIUS AND ALBERTI, HE SET FORTH HIS ARCHITECTURAL TREATISE IN *QUATTRO LIBRI DELL' ARCHITECTURA.* THIS BOOK BECAME A MANUAL THAT WOULD INFLUENCE DESIGN FOR MORE THAN TWO CENTURIES.

PALLADIO'S ARCHITECTURE AND THEORIES AROSE FROM HIS STUDY OF ANCIENT BUILDINGS. HIS DESIGNS WERE BASED PRINCIPALLY ON PROPORTIONS, SYMMETRY, AND THE TEMPLE FRONT. HIS MOST INFLUENTIAL DESIGNS WERE HIS VILLAS, THE HALLMARKS OF "PALLADIANISM." PALLADIO IS A PRIME EXAMPLE OF THE RENAISSANCE MISSION: TO DISCOVER ANTIQUITY, TO REVIVE AND INTERPRET IT.

THE VILLA CRAPPERIA IS AN EXAMPLE OF THE PURITY OF HIS WORK. STRICTLY SYMMETRICAL AND HARMONICALLY PROPORTIONED, IT RESPECTS ITS CLASSICAL MODELS. THE TEMPLE FRONT APPLIED TO THIS BUILDING IS SIMILAR TO MANY OTHER VILLAS. HERE THE SYMBOLISM IS WELL JUSTIFIED IN THAT THE FUNCTION OF THE HOUSE IS A NATURAL ACT ORIGINATING FROM THE HANDS OF THE GODS.

OUTHOUSES BY FAMOUS ARCHITECTS

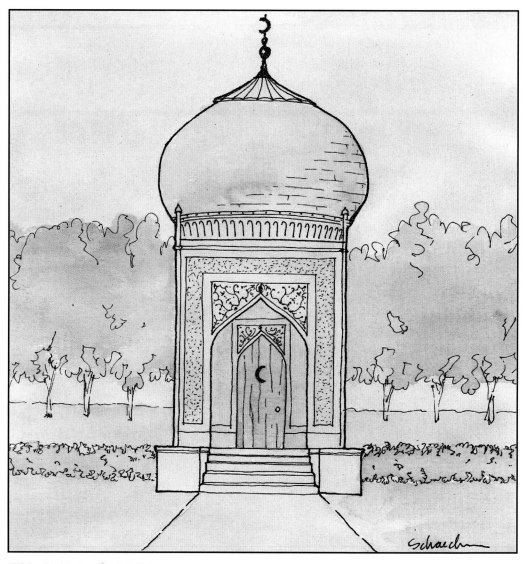

TAJ MA-STALL

EMPEROR SHAH JAHAN

BORN 1592, AGRA
DIED 1666, AGRA

EMPEROR SHAH JAHAN'S FULL NAME WAS KHURRAM SHIHAB-UD-DIN MUHAMMAD. HE RULED AS EMPEROR OF INDIA FROM 1628 TO 1658. DURING HIS REIGN HE CONQURED THE DECCAN AND TEMPORARILY RECOVERED KANDAHAR FROM THE PERSIANS. HIS REIGN IS CONSIDERED THE GOLDEN AGE OF ART AND ARCHITECTURE FOR THE MUGHAL. JAHAN FELL ILL IN 1657; THIS LED TO A WAR OF SUCCESSION BETWEEN HIS SONS. HE WAS IMPRISONED BY HIS SON AURANGZEB FOR THE REMAINING EIGHT YEARS OF HIS LIFE.

ONE OF SHAH JAHAN'S GREATEST ACHIEVEMENTS WAS THE CONSTRUCTION OF THE TAJ MAHAL. THIS BUILDING'S FUNCTION IS AS A MAUSOLEUM FOR THE SHAH'S WIFE. ONE OF THE "SEVEN WONDERS OF THE WORLD," IT IS ONE OF THE MOST MAGNIFICENT STRUCTURES EVER CREATED. ITS USE OF INLAID STONE PATTERNS AND ORNAMENTATION ARE EXQUISITE, YET ITS TRUE BEAUTY LIES IN ITS PERFECT BALANCE AND PROPORTIONS. IT IS THE QUINTESSENTIAL STATEMENT OF ISLAMIC ARCHITECTURE.

TO ACCOMMODATE THE MILLIONS OF VISITORS ANTICIPATED FOR THE TAJ MAHAL, THE SHAH HAD AN OUTHOUSE CONSTRUCTED NEXT TO IT. THIS MAGNIFICENT STRUCTURE IS AS REMARKABLE AS THE TAJ MAHAL. THE EXQUISITE MATERIALS AND THE BUILDING'S FORMALITY MAKE THE VISITOR FEEL AS THOUGH HE OR SHE IS A MEMBER OF THE ROYAL FAMILY, SEATED ON THE THRONE.

OUTHOUSES BY FAMOUS ARCHITECTS

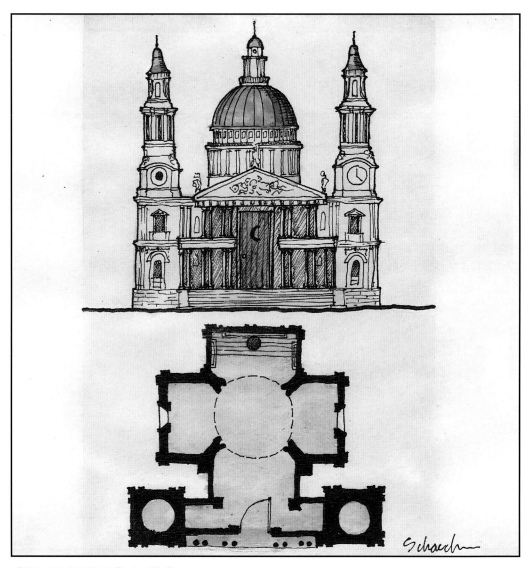

ST. PAUL'S LOO

SIR CHRISTOPHER WREN

BORN 1632, WILTSHIRE, ENGLAND
DIED 1723, LONDON

AFTER STUDYING AT WADHAM COLLEGE IN OXFORD, WREN WORKED
AS AN ASSISTANT TO AN ANATOMIST, WHICH HELPED HIM DEVELOP
SKILLS AS A SCIENTIFIC THINKER. HE BECAME A PROFESSOR OF
ASTRONOMY IN 1657. SIR ISAAC NEWTON COMMENTED THAT WREN
WAS ONE OF "THE GREATEST GEOMETERS OF OUR TIME." HE WAS
LATER TO BE APPOINTED SURVEYOR-GENERAL OF THE KING'S WORKS.

THE DEVASTATING 1666 FIRE IN LONDON PLACED WREN IN A POSI-
TION THAT ALLOWED HIS ARCHITECTURAL TALENTS TO EMERGE. HIS INGE-
NIOUS PLAN TO REBUILD THE CITY WAS REJECTED BECAUSE IT WOULD
HAVE REQUIRED EXTENSIVE REORGANIZING OF ESTABLISHED PROPERTIES.
HOWEVER, PART OF HIS PLAN WAS REALIZED IN THE REBUILDING OF
MORE THAN FORTY LONDON CHURCHES. WREN USED THIS OPPORTUNITY
TO INCORPORATE HIS IMPRESSIONS OF ARCHITECTURE, INTRODUCING
ENGLAND TO THE BAROQUE STYLE. WREN ENVISIONED THE CHURCHES
AS AUDITORIUMS WHERE LAITY AND CLERGY WOULD ENGAGE IN THE
SERVICES TOGETHER, AND WHERE UNINTERRUPTED SPACE AND LIGHT
WOULD ENCOURAGE THE SPIRIT OF THE SPACE.

ONE OF WREN'S REBUILT SANCTUARIES IS ST. PAUL'S LOO. DURING
THE REBUILDING PERIOD, SANITARY FACILITIES WERE RARE. THE LOO WAS
AN OASIS FOR THE CITIZENS OF LONDON. IT WAS ALSO ONE OF THE
FIRST FACILITIES TO INCORPORATE PROVISIONS FOR THE DISABLED, IN THE
FORM OF GRAB BARS AND A FIVE-FOOT-DIAMETER TURNING AREA. THESE
PROVISIONS SECURED A KNIGHTHOOD FOR WREN IN 1673.

OUTHOUSES
BY FAMOUS ARCHITECTS

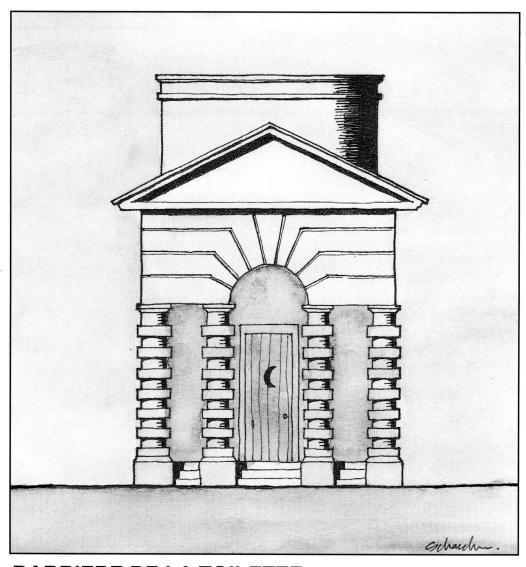

BARRIERE DE LA TOILETTE

CLAUDE-NICOLAS LEDOUX

BORN 1736, DORMANS, FRANCE
DIED 1806, PARIS

LEDOUX STUDIED ARCHITECTURE AT A PRIVATE SCHOOL IN PARIS, THEN WENT ON TO BECOME A VERY TALENTED INTERIOR DECORATOR AND TO PRODUCE A SERIES OF ELEGANT PARISIAN HOMES IN THE LATE 1760S. THESE HOMES MADE HIS NAME AS AN ARCHITECT AND EVENTUALLY SECURED HIM A MEMBERSHIP IN THE ACADÉMIE ROYALE D'ARCHITECTURE. HE ALSO UNDERTOOK A SERIES OF GOVERNMENT PROJECTS THAT WERE PIVOTAL IN THE DEVELOPMENT OF HIS CRAFT.

LEDOUX'S DEVELOPMENT ORIGINATED FROM A WARPED VIEW OF ROMAN ARCHITECTURE. HE HAD NEVER VISITED ITALY AND DERIVED HIS STYLINGS FROM A PERIODICAL CALLED *PIRANESI*. LEDOUX IS CONSIDERED A VISIONARY BECAUSE OF HIS ABSTRACTION OF CLASSICAL ARCHITECTURE. HIS EXAGGERATION OF THE PROPORTIONS OF CLASSICAL ELEMENTS SEEMS TO ANTICIPATE POSTMODERNISM.

IN 1783, THE CITY OF PARIS AWARDED LEDOUX A COMMISSION FOR A SERIES OF FIFTY TOLL GATES (*BARRIERES*) AROUND THE CITY. LEDOUX'S DESIGNS WERE CONSIDERED TOO LAVISH AND COSTLY, AND HE WAS REMOVED FROM THE JOB; HOWEVER, MANY OF HIS PLANS WERE REALIZED, THANKS TO THE SUPPORT OF A SYMPATHETIC FOLLOWER. ONE SADLY UNREALIZED DESIGN WAS FOR THE BARRIERE DE LA TOILETTE. THIS STRUCTURE WAS CONSIDERED ONE OF HIS GREATEST WORKS, BECAUSE IT COMBINED THE FUNCTION OF THE OUTHOUSE WITH THAT OF THE TOLL BOOTH—IN EFFECT, A PRECURSOR OF THE PAY TOILET.

OUTHOUSES BY FAMOUS ARCHITECTS

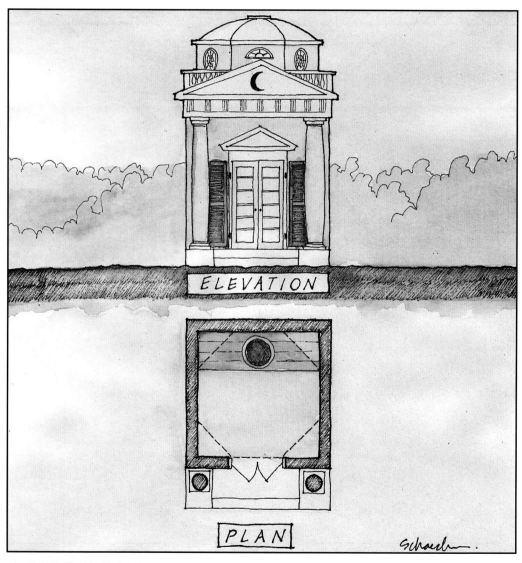

JOHNICELLO

THOMAS JEFFERSON

BORN 1743, SHADWELL, VIRGINIA
DIED 1826, MONTICELLO, VIRGINIA

WHILE THOMAS JEFFERSON IS BEST KNOWN AS THE THIRD PRESIDENT OF THE UNITED STATES OF AMERICA, HE COULD AS WELL BE CONSIDERED A JACK-OF-ALL-TRADES. ONE OF HIS TRADES WAS THE PRACTICE OF ARCHITECTURE, ALTHOUGH HE HAD NO FORMAL TRAINING IN THE FIELD. JEFFERSON AND HIS CONTEMPORARY BENJAMIN LATROBE WERE INSTRUMENTAL IN THE SHIFT FROM COLONIAL STYLE TO FEDERAL STYLE.

JEFFERSON WAS STRONGLY INFLUENCED BY THE WORK OF ANDREA PALLADIO AND HIS BOOK *QUATTRO LIBRI*. HE ADMIRED THE POWERFUL POLITICAL QUALITIES APPARENT IN THE ANCIENT ROMAN STRUCTURES. HIS WORKS DEMONSTRATED THE CHANGING POLITICAL AND ARCHITECTURAL TRENDS OF HIS TIME. JEFFERSON'S LACK OF TRAINING ADDED SOME ECCENTRIC DETAILING AND QUIRKINESS TO HIS DESIGNS: THEY WERE NOT AS PURE AS THE ORIGINALS FROM WHICH THEY WERE DERIVED.

JEFFERSON DESIGNED HIS OWN HOUSE, MONTICELLO. HE GAVE THE NAME "JOHNICELLO" TO HIS OUTBUILDING, WHICH STRONGLY EMBODIED THE ARCHITECT'S PALLADIAN INFLUENCES. IT IS THOUGHT THAT JEFFERSON VISITED THE HOUSE WHEN HE WANTED TO SHOW HIS TRUE APPRECIATION FOR POLITICS. SOME HISTORIANS HAVE SPECULATED THAT THERE WAS A HIDDEN SLAVE ENTRANCE TO THE HOUSE, BUT NO EVIDENCE HAS BEEN DISCOVERED TO SUPPORT THIS.

OUTHOUSES
BY FAMOUS ARCHITECTS

MARSHALL FIELD'S NO. 2 STORE

HENRY HOBSON RICHARDSON

BORN 1838

DIED 1886

H. H. RICHARDSON ATTENDED THE ÉCOLE DES BEAUX-ARTS IN PARIS IN THE EARLY 1860S. HIS WORK PERSONALIZED THE ROMANESQUE STYLE, INTEGRATING FINE MATERIALS AND PRINCIPLES OF OTHER STYLES. HE IS CONSIDERED ONE OF THE GREATEST AMERICAN ARCHI-TECTS AND WAS ONE OF THE FIRST TO REACH INTERNATIONAL STATURE.

TRADEMARKS OF THE "RICHARDSONIAN ROMANESQUE" STYLE INCLUDE ITS USE OF RUSTICATED MASONRY, ROUND ARCHES, AND COLONNETTES. THE EXTERIORS OF HIS BUILDINGS ARE MASSIVE, CARVED OBJECTS. THE PLAN AND MASSING DEMONSTRATE THE INFLUENCE OF HIS FRENCH EDU-CATION, AND THE MATERIALS HARKEN TO THE HIGH VICTORIAN STYLE, WITH AN ARRAY OF RICH TEXTURES AND COLORS.

THE MARSHALL FIELD STORE IN CHICAGO WAS NOTED AS BEING HIS MASTERPIECE. ALONG WITH THE NO. 2 STORE, IT WAS SHAME-LESSLY DESTROYED IN 1931 TO MAKE WAY FOR A PARKING LOT. THE BUILDINGS ESTABLISHED A NEW APPROACH TO THE HIGH-RISE BUILDING, WITH A DISTINCT BASE, MIDDLE, AND TOP, AND A PROGRESSION OF SHAPES THAT LEAD THE EYE SKYWARD.

THE NO. 2 STORE (ACTUALLY CONSTRUCTED FIRST) WAS THE MOST POPULAR BUILDING IN TOWN. THE STONE ON THE BUILDING, ORIGINALLY SMOOTH, BECAME RUSTICATED AFTER YEARS OF EXPOSURE TO THE ELEMENTS OF ITS USERS. RICHARDSON LIKED THIS EFFECT SO MUCH THAT HE INTEGRATED IT INTO HIS FUTURE DESIGNS.

OUTHOUSES BY FAMOUS ARCHITECTS

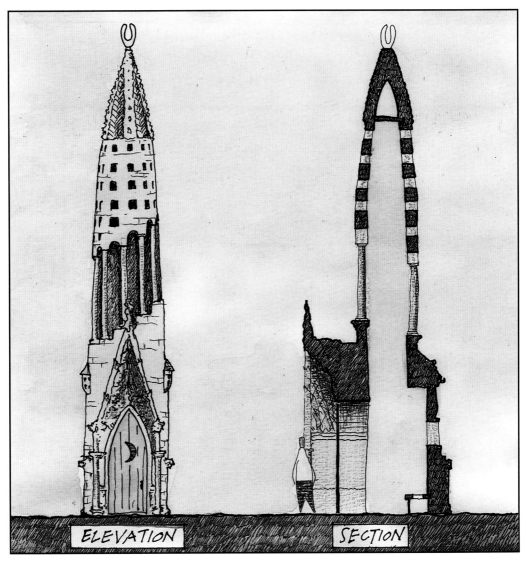

SAGRADA LATRINA

ANTONIO GAUDI

BORN 1852, REUS, SPAIN
DIED 1926, BARCELONA

The son of a coppersmith, Antonio Gaudi studied architecture at Escola Superior d'Arquitectura in Barcelona. His work is often classified as Art Nouveau, but it is clearly a distinct style all its own. Gaudi's first major commission was for the Casa Vincens in Barcelona; the Gothic Revival style that he utilized would later be incorporated into other works.

Gaudi was influenced by many movements. Perhaps the largest contributor to his style was the writing of Viollet-le-Duc, who advocated "organic rationalism." Gaudi took this approach to an extreme and incorporated organic elements into his designs, going so far as to build structures that resembled skeletons. He insisted that there were no straight lines in nature and developed his designs to look like abstract organisms from some faraway fantasy world. His work was admired for its genius and creativity.

Gaudi was working on his masterpiece, the Church of the Sagrada Familia, when he died. The cathedral is still under construction today. However, Gaudi's Sagrada Latrina was realized during his lifetime. Gothic influences can be seen in this design, yet it has a character of its own. The feeling of being inside an organism is escalated in the function of the Latrina. The design reminds the user of the primitive nature of life and its essential necessities.

OUTHOUSES
BY FAMOUS ARCHITECTS

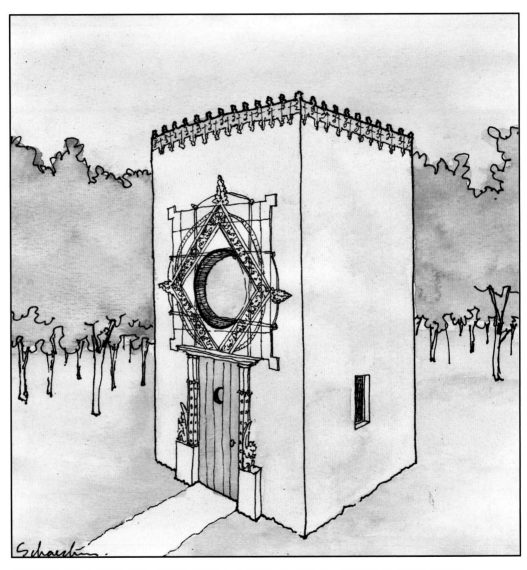

MERCHANTS FIRST NATIONAL OUTHOUSE

LOUIS SULLIVAN

BORN 1856, BOSTON
DIED 1924, CHICAGO

LOUIS SULLIVAN STUDIED ARCHITECTURE AT M.I.T. AND THE ÉCOLE DES BEAUX-ARTS. HE THEN PRACTICED ARCHITECTURE IN CHICAGO. IN PARTNERSHIP WITH DANKMAR ADLER, SULLIVAN BECAME A PROMINENT FIGURE IN THE EARLY MODERN MOVEMENT OF THE TIME. SULLIVAN'S FAMOUS PHRASE, "FORM FOLLOWS FUNCTION," BECAME A MOTTO FOR MANY ARCHITECTS.

SULLIVAN BELIEVED IN EXPRESSING FUNCTION ORGANICALLY OR "EVOLUTIONISTICALLY." HIS DESIGNS WERE OFTEN SIMPLE BOXES WITH HIGHLY ORNAMENTED ORGANIC SYMBOLS OF LIFE APPLIED TO THEM. AN ORGANIZER AND FORMAL THEORIST ON AESTHETICS, HE PUSHED FOR AN ARCHITECTURE THAT EXHIBITED THE SPIRIT OF THE TIME AND THE NEEDS OF THE PEOPLE. HE IS RUMORED TO HAVE COINED THE TERM "NATURE'S CALLING."

SULLIVAN'S OUTHOUSE EXEMPLIFIES HIS PHILOSOPHIES. THE FUNC-TION OF THE OUTHOUSE MEETS WHAT IS ARGUABLY THE MOST IMPOR-TANT NEED OF THE PEOPLE. THE ORGANIC NATURE OF THE ORNAMENTATION IS IMMENSELY APPROPRIATE TO THE BIODEGRADABLE FUNCTION OF THE OUTHOUSE. SULLIVAN'S WORK IS TRULY TO BE CELE-BRATED AND ENJOYED IN ALL ITS ASPECTS.

OUTHOUSES BY FAMOUS ARCHITECTS

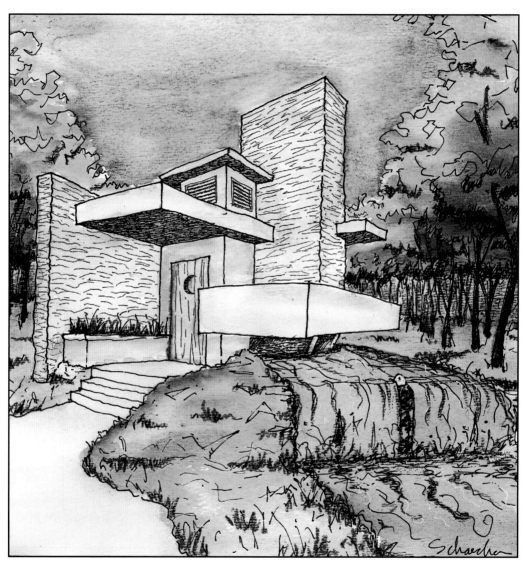

FLUSHINGWATER

FRANK LLOYD WRIGHT

BORN 1867, RICHLAND CENTER, WISCONSIN
DIED 1959, TALIESIN WEST, ARIZONA

FRANK LLOYD WRIGHT'S IS PROBABLY THE MOST RECOGNIZABLE NAME IN ARCHITECTURE. HE IS HERALDED AS THE GREATEST ARCHITECT OF THE TWENTIETH CENTURY. HIS PHILOSOPHIES AND DESIGN APPROACH HAVE INSPIRED ARCHITECTS AND ARTISTS EVERYWHERE.

WRIGHT WAS A PIONEER OF "BREAKING OUT OF THE BOX"—THE BOX THAT ARCHITECTURE HAD BEEN IN FOR CENTURIES. HE ACHIEVED THIS BY DEVELOPING OPEN PLANS THAT ALLOW FUNCTIONAL SPACES TO OVER-LAP. HIS APPROACH, WHICH CAME TO BE KNOWN AS THE PRAIRIE STYLE, HAD A HORIZONTAL EMPHASIS AND CROSS-AXIALITY WITH LONG, LOW, HOVERING PLANES. WRIGHT REFERRED TO THE ABSTRACTION OF NATURE'S PRINCIPLES AS "ORGANIC ARCHITECTURE." HIS LATER WORKS MAINTAINED HIS EARLY PRINCIPLES, BUT INCORPORATED ELEMENTS OF THE MODERN MOVEMENT. THIS STAGE IN HIS CAREER LED TO SOME OF HIS GREATEST WORKS AND ELEVATED HIM TO A PLATEAU OF GENIUS.

·FLUSHINGWATER WAS A PREDECESSOR TO WRIGHT'S MASTERPIECE, FALLINGWATER. THE CONCEPT OF PLACING THE STRUCTURE DIRECTLY OVER THE WASTEWATER WAS FIRST EXPLORED HERE. THOUGH THE CLEANER WATER OF FALLINGWATER HAS MADE IT A MORE POPULAR ATTRACTION TO THE MASSES, THIS DESIGN DRAWS UPON THE STRENGTH AND SERENITY OF ITS SURROUNDINGS IN DRAMATIC FASHION, SYMBOLIZING THE CONNECTION OF MAN AND NATURE. IT IS TRULY A MONUMENT TO SOLITUDE.

OUTHOUSES BY FAMOUS ARCHITECTS

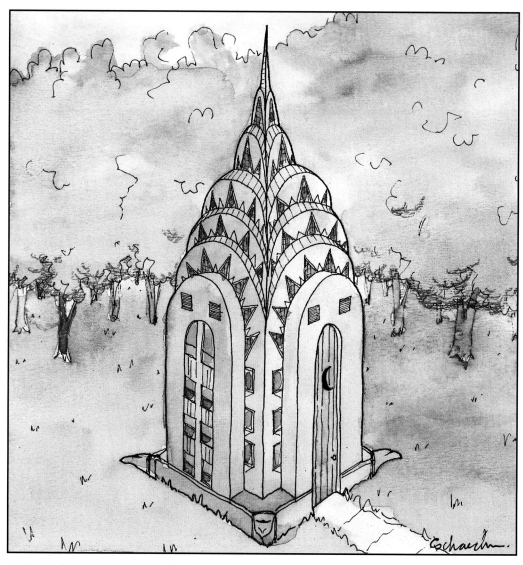

THE SCHEISTLER BUILDING

WILLIAM VAN ALEN

BORN 1883, BROOKLYN, NEW YORK
DIED 1954, NEW YORK CITY

WILLIAM VAN ALEN STUDIED AT PRATT INSTITUTE IN BROOKLYN,
WORKED FOR SEVERAL NEW YORK OFFICES, AND THEN WAS
AWARDED THE LLOYD WARREN FELLOWSHIP. THIS ALLOWED HIM TO
TRAVEL TO EUROPE AND FURTHER HIS STUDIES AT THE ÉCOLE DES
BEAUX-ARTS IN PARIS.

ON HIS RETURN TO NEW YORK, VAN ALEN WENT INTO PARTNER-
SHIP WITH H. CRAIG SEVERANCE. THEIR FIRM BECAME KNOWN FOR ITS
APPROACH TOWARD MULTISTORY BUILDINGS, WHICH ABANDONED THE
COMMON PRACTICE OF EMULATING COLUMN ELEMENTS (BASE, SHAFT,
AND CAPITAL).

VAN ALEN WENT ON TO FORM HIS OWN PRACTICE. HIS MOST
PROMINENT PROJECT WAS THE CHRYSLER BUILDING, CONSIDERED ONE
OF THE GREAT MONUMENTS IN AMERICA AND THE MOST MAGNIFICENT
EXAMPLE OF THE ART DECO STYLE.

THE SHEISTLER BUILDING WAS CONSTRUCTED WHILE THE CHRYSLER
BUILDING WAS BEING DESIGNED. IT WAS USED BY VAN ALEN NOT
ONLY TO HELP DETERMINE THE CROWN TO HIS MONUMENT, BUT ALSO
AS A HAVEN IN WHICH TO STUDY WITHOUT INTERRUPTION. THE ART
DECO STYLE IS WHOLLY APPROPRIATE TO THE STRUCTURE, IN LIGHT OF
THE MOVEMENT'S FOCUS ON ARTISTIC EXPRESSION THAT COMPLE-
MENTED THE MACHINE AGE. THE SHEISTLER BUILDING PROVIDED VAN
ALEN A PERSONAL THEATER FOR THE EXPRESSION OF HIS CREATIVITY—
AND PROVIDED SOCIETY WITH A NEW ICON.

**OUTHOUSES
BY FAMOUS ARCHITECTS**

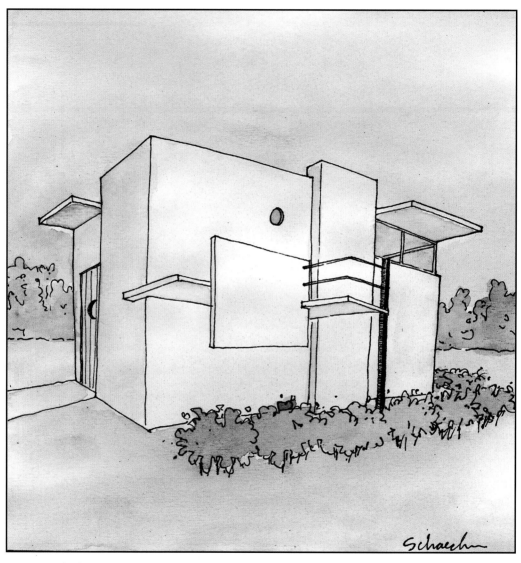

THE SCHEISSE HOUSE

GERRIT RIETVELD

BORN 1888, UTRECHT
DIED 1964, UTRECHT

GERRIT RIETVELD WORKED IN HIS FATHER'S JOINERY BUSINESS, AND THEN APPRENTICED AT A JEWELRY STUDIO. HE STARTED HIS OWN CABINETMAKING PRACTICE IN 1911. DURING HIS EIGHT YEARS RUNNING THIS SHOP, HE STUDIED ARCHITECTURE. ALONG WITH OTHER ARTISANS, WRITERS, AND ARTISTS OF THE TIME, HE HELPED FOUND DE STIJL (THE STYLE), A MOVEMENT TO ESTABLISH A UNIVERSAL MODERN STYLE THAT WAS APPLICABLE ACROSS ALL THE ARTS.

DE STIJL WAS COMMITTED TO SATISFYING SPIRITUAL AND PHYSICAL NEEDS THROUGH ARCHITECTURE, FOCUSING ON AESTHETIC CONCERNS OVER STRUCTURE AND FUNCTION. DESIGNS BY DE STIJL UTILIZED FREE AND VARIABLE USE OF SPACE, CREATING A DYNAMIC INTERPLAY OF FORMS. THE WORKS WERE OFTEN INSPIRED BY ABSTRACT ELEMENTARIST ARTWORK OF PRIMARY SHAPES AND COLORS. THE FIRST PRODUCT REPRESENTING THIS PHILOSOPHY WAS A CHAIR DESIGNED BY RIETVELD IN 1917.

RIETVELD'S SCHEISSE HOUSE IS A PRIME EXAMPLE OF DE STIJL'S PHILOSOPHY. THIS OUTHOUSE IS FORMED BY A SERIES OF PLANES COMING TOGETHER TO DEFINE SPACE. THE USER TRULY FEELS AS THOUGH HE OR SHE IS INSIDE ARTWORK. THE STRUCTURE'S ASYMMETRY SYMBOLIZES THE DELICATE BALANCE OF LIFE AND THE ESSENTIAL ROLE OF THE OUTHOUSE. RIETVELD'S BACKGROUND IN FURNITURE LED HIM TO INCORPORATE MANY CABINETLIKE DEVICES INTO THE FACILITY TO HIDE TOILET ACCESSORIES.

OUTHOUSES
BY FAMOUS ARCHITECTS

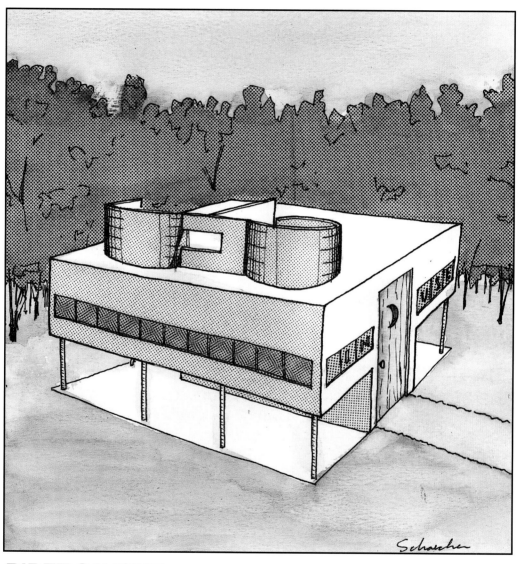

BIDET SAVOYE

LE CORBUSIER

BORN 1887, LA CHAUX DE FONDS, SWITZERLAND
(AS CHARLES-ÉDUOARD JEANERET)
DIED 1965, CAP MARTIN, FRANCE

LE CORBUSIER WAS THE LEADER IN THE HIGH MODERNIST MOVE-
MENT. HIS ACHIEVEMENTS IN THE ARCHITECTURE OF THE TWENTIETH
CENTURY ARE RIVALED ONLY BY FRANK LLOYD WRIGHT AND MIES
VAN DER ROHE.

LE CORBUSIER'S THEORY AND PRACTICE IN ARCHITECTURE COMBINED
CLASSICAL IDEALISM OF FORM, THE AGE OF INDUSTRY AND MACHINES,
AND ABSTRACT ART. HE PERCEIVED "ARCHITECTURE" AS THAT PORTION
OF A STRUCTURE THAT TOUCHES YOUR HEART AND MOVES YOU—THE
PLACE WHERE ART ENTERS IN—AND BELIEVED IN THE EXPRESSION OF
THE PURITY OF FORMS AND THE PLAY OF LIGHT ON THESE FORMS. LE
CORBUSIER OBSERVED THAT "A HOUSE IS A MACHINE FOR LIVING IN."
THIS PHILOSOPHY PLAYED THROUGH IN HIS DESIGNS, EMBRACING
MACHINE-AGE MATERIALS AND METHODS OF CONSTRUCTION. HIS BUILD-
INGS WERE OFTEN CONSTRUCTED OF POURED CONCRETE WITH ARTICU-
LATED STRUCTURE; THIS IS ESPECIALLY EVIDENT IN THE WORK OF HIS
LATER YEARS.

IN THE BIDET SAVOYE, WE SEE A MARRIAGE OF MACHINE AND MAN.
BELIEVED TO BE ONE OF THE FIRST OUTHOUSES WITH BUTT-WASHING
CAPABILITIES, IT EXEMPLIFIES LE CORBUSIER'S DEFINITION OF ARCHITEC-
TURE. THE USER IS INSPIRED TO BECOME AN ARTIST. SIMPLICITY OF
FORM AND SPACE DEMONSTRATES PURITY OF FUNCTION.

OUTHOUSES BY FAMOUS ARCHITECTS

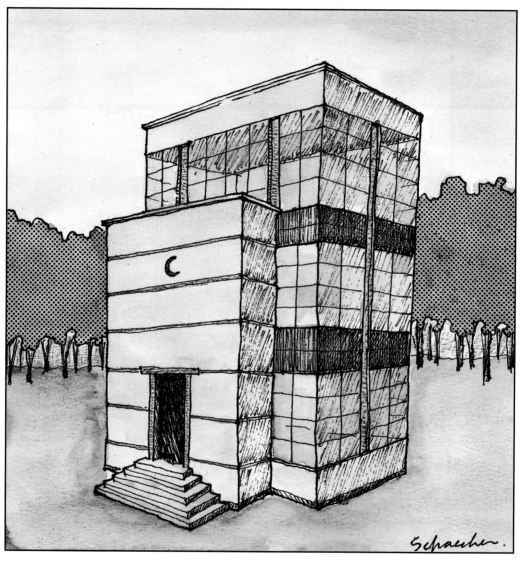

AUTHAUS

WALTER GROPIUS

BORN 1883, BERLIN
DIED 1969, BOSTON

THE SON OF AN ARCHITECT, WALTER GROPIUS STUDIED AT THE TECHNICAL UNIVERSITIES OF MUNICH AND BERLIN, THEN WORKED IN THE OFFICE OF PETER BEHRENS (AS DID MIES VAN DER ROHE AND LE CORBUSIER). AFTER THREE YEARS UNDER BEHRENS, GROPIUS BEGAN HIS OWN PRACTICE IN PARTNERSHIP WITH ADOLPH MEYER.

GROPIUS'S DESIGNS ESTABLISHED A DIVISION BETWEEN THE OLDER GENERATION OF ARCHITECTS AND HIS OWN GENERATION. PUSHING THE MODERNISM ENVELOPE TO BREAK AWAY FROM CLASSICAL FORMATIONS, GROPIUS EMBRACED THE PRECISION AND STANDARDIZATION OF CONSTRUCTION THAT WAS BEING DEVELOPED WITH THE INDUSTRIAL AGE. HE WAS ALSO INVOLVED IN MANY RADICAL ARTISTS' GROUPS OF THE TIME, AND EVENTUALLY HELPED TO FOUND AND LEAD THE BAUHAUS—A SCHOOL DEDICATED TO BRIDGING THE GAP BETWEEN THE ARTISTIC AND INDUSTRIAL WORLDS.

AUTHAUS IS ONE OF HIS FINEST WORKS. THE CURTAIN WALL HE DEVELOPED DISTINCTLY SEPARATES THE STRUCTURE OF THE BUILDING FROM ITS SKIN. IT ALSO OFFERS THE USER A VISUAL CONNECTION WITH THE EXTERIOR. THE ART OF THE STRUCTURE EFFECTIVELY INFLUENCES THE MASS PRODUCTION OF THE USERS. THIS BUILDING PLAYED A PIVOTAL ROLE, EMBRACING OPENNESS FOR FUTURE OUTHOUSES AND BREAKING DOWN HUMILIATION BARRIERS IN THOSE WHO FREQUENT THEM.

OUTHOUSES BY FAMOUS ARCHITECTS

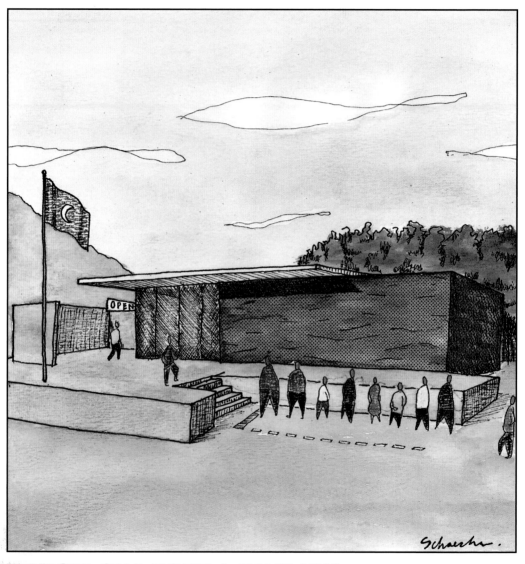

BARCELONA PORT-A-PAVILION

LUDWIG MIES VAN DER ROHE

BORN 1886, AACHEN, GERMANY
DIED 1969, CHICAGO

LUDWIG MIES VAN DER ROHE STUDIED ARCHITECTURE UNDER PETER BEHRENS AND EVENTUALLY DEVELOPED A DESIGN APPROACH BASED ON STRUCTURAL TECHNIQUES. HIS SPATIAL PLANNING, USING FLOATING PLANES TO DEFINE SPACES, WAS INFLUENCED BY THE DUTCH DE STIJL MOVEMENT.

MIES' STRUCTURAL RATIONALISM EVOLVED INTO A SIMPLIFIED ARCHITECTURE. HE DID NOT PARTICIPATE MUCH IN THE RHETORIC OF HIS TIME—BUT HE IS FAMOUS FOR HIS OBSERVATION, "LESS IS MORE." HIS BUILDINGS STRIVED TO EPITOMIZE HIS MOTTO THROUGH PERFECTION OF STRUCTURE, PROPORTIONS, AND DETAIL. LATER IN HIS CAREER HE EMBRACED THE USE OF STRUCTURAL SKELETONS FOR BUILDINGS. THE SKELETAL SYSTEM, ALONG WITH HIS MODERNIST PRINCIPLES, ALLOWED HIM TO BEGIN THE NEW ERA OF SKYSCRAPERS AND THE GLASS CURTAIN WALL.

THE BARCELONA PAVILION IS ONE OF HIS MASTERPIECES. TO BALANCE THIS PIECE AT THE INTERNATIONAL EXPOSITION OF 1929, HE ALSO CREATED THE PORT-A-PAVILION. THE PORT-A-PAVILION MIMICKED THE OTHER PAVILION BUT WAS IN SOME RESPECTS MORE POPULAR. HISTORIANS HAVE NOTED THAT THERE WAS ALWAYS A LINE TO USE THE FACILITY (SOMETIMES AS LONG AS FIFTEEN MINUTES). USERS STATED THAT THE EXOTIC MATERIALS AND SIMPLICITY OF FORM INSPIRED THEM TO "TAKE THEIR TIME AND DO THINGS RIGHT"(AND TO ENJOY THEIR SURROUNDINGS, NO DOUBT). HIS MOTTO FOR THIS FACILITY WAS "LESS IS QUICKER."

OUTHOUSES BY FAMOUS ARCHITECTS

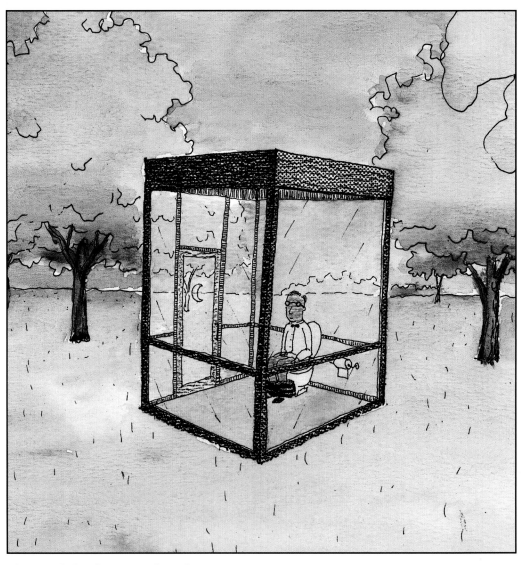

GLASS OUTHOUSE

PHILIP JOHNSON

BORN 1906, CLEVELAND, OHIO

JOHNSON GRADUATED FROM HARVARD IN 1930 WITH A DEGREE IN ARCHITECURAL HISTORY. AS DIRECTOR OF THE DEPARTMENT OF ARCHITECTURE FOR THE MUSEUM OF MODERN ART, NEW YORK, HE CO-DIRECTED A MOMA EXHIBITION THAT INTRODUCED EUROPEAN MODERN ARCHITECTURE TO AMERICA. HE RETURNED TO HARVARD IN 1940 TO EARN A DEGREE IN ARCHITECTURE.

JOHNSON WENT ON TO PRACTICE ARCHITECTURE WITH SEVERAL PARTNERS OVER TIME. HE WAS AN ADVOCATE OF MIES VAN DER ROHE'S WORK EARLY IN HIS CAREER, EMBRACING MIESIAN PHILOSO-PHIES IN HIS OWN WORKS. OVER TIME, JOHNSON HAS ALTERED HIS ARCHITECTURAL PRINCIPLES FROM MODERNIST TO POSTMODERNIST TO DECONSTRUCTIVIST WITHOUT DISCRETION. HE HAS BEEN CRITICIZED FOR THIS BANDWAGON ATTITUDE, YET HE HAS EFFECTIVELY STIMULATED THE DISCOURSE OF THESE ARCHITECTURAL TRENDS.

JOHNSON'S GLASS HOUSE IS HIS BEST KNOWN WORK. THIS WAS HIS OWN PERSONAL RESIDENCE. PRIOR TO HIS GLASS HOUSE, HE EXPERIMENTED WITH THIS IDEA WITH HIS GLASS OUTHOUSE. THE SHOWCASE QUALITY WAS CRITICIZED BY SOME, BUT JOHNSON ENJOYED THE EXHIBITIONISM. ONE PROPONENT OF THE FACILITY OBSERVED, "YOU FEEL AS THOUGH YOU ARE 'GOING' IN THE WOODS, YET YOU ARE PROTECTED FROM RAIN, AND YOU'VE GOT TOILET PAPER HANDY. YOU CAN'T BEAT THAT." JUSTIFIED PRAISE FOR A CONTROVER-SIAL CRAPPER.

OUTHOUSES BY FAMOUS ARCHITECTS

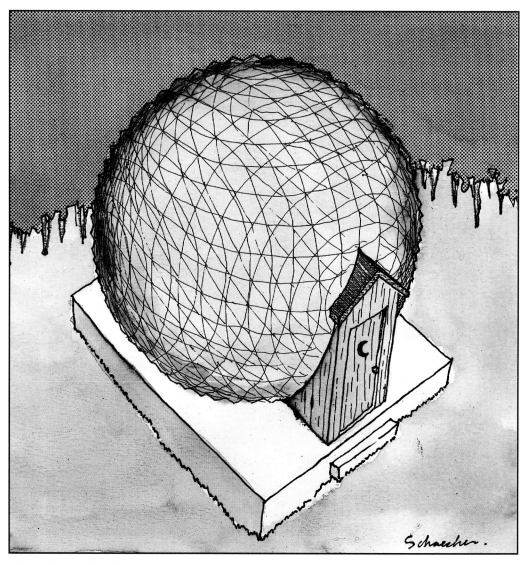

GEODESIC THRONE

R. BUCKMINSTER FULLER

BORN 1895, MILTON, MASSACHUSETTS
DIED 1983, LOS ANGELES

BUCKMINSTER FULLER WAS A NOTED PHILOSOPHER, ENGINEER, INVENTOR, DESIGNER, WRITER, EDUCATOR, AND ARCHITECT. HE WAS ALSO AN INNOVATIVE, PIONEERING FUTURIST WHO SOUGHT TO RESOLVE THE PROBLEMS FACING THE EARTH AND HUMANKIND THROUGH THE USE OF TECHNOLOGY. HIS BASIC APPROACH CAN BE REDUCED TO HIS IMPERATIVE: "DO MORE WITH LESS."

FULLER FOCUSED ON INVENTIONS THAT WERE ECONOMICAL AND COULD BE MASS PRODUCED. HIS MOST NOTABLE INVENTION WAS THE GEODESIC DOME, COMPRISING STANDARDIZED PARTS AND CAPABLE OF SPANNING GREAT AREAS WITH HIGH EFFICIENCY. HE UTILIZED MATHEMATICAL PRINCIPLES TO ESTABLISH HIS OPTIMIZATION OF PARTS TO THE WHOLE.

THE GEODESIC THRONE PAYS HOMAGE TO HUMANITY'S WASTE. THE USERS BECOME THE FOCUS OF MASS PRODUCTION PRINCIPLES BY THEIR OWN PRODUCTION OF MASS INSIDE. THE THRONE'S SIMPLICITY OF FORM, STRUCTURE, AND FUNCTION INSPIRES THEM TO CONSIDER HOW TECHNOLOGY CAN SOLVE THE FUTURE AND IMMEDIATE NEEDS OF THE WORLD.

OUTHOUSES BY FAMOUS ARCHITECTS

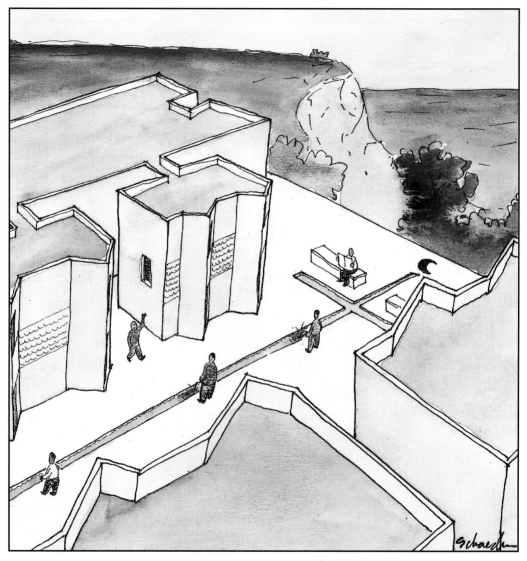

TROUGH INSTITUTE OF BIOLOGICAL STUDIES

LOUIS I. KAHN

BORN 1901, SAARAMA, ESTONIA
DIED 1974, NEW YORK CITY

LOUIS KAHN'S FAMILY MOVED TO THE UNITED STATES FROM ESTONIA
IN 1905. HE STUDIED ARCHITECTURE AT THE UNIVERSITY OF
PENNSYLVANIA, FROM A FACULTY THAT EMBRACED THE BEAUX-ARTS
TRADITIONS. IN THE 1920S AND EARLY 1930S HE WORKED FOR SEV-
ERAL PHILADELPHIA-BASED OFFICES; STARTING IN 1935 HE FORMED
SEVERAL SUCCESSIVE PARTNERSHIPS. FROM 1948 ON, KAHN WORKED
ALONE. HE EVENTUALLY WENT BACK TO THE UNIVERSITY OF
PENNSYLVANIA TO SERVE AS DEAN.

KAHN'S ARCHITECTURE WAS ROOTED IN MODERNISM YET IT DIFFERED
IN ITS APPROACH. HIS BEAUX-ARTS TRAINING FOCUSED HIS APPROACH
TO DESIGN AROUND THE FUNCTION OF THE BUILDING IN QUESTION. HIS
CREATIONS CONSISTED OF SIMPLE GEOMETRIC FORMS, LAID OUT IN FOR-
MAL SCHEMES AND DOMINATED BY A COMPLEX CONFIGURATION OF
SYMMETRICAL AXES AND CROSS-AXES. THESE DESIGNS WERE MONU-
MENTAL, YET THEY MAINTAINED A SYMPATHY FOR THEIR SITE.

THE TROUGH INSTITUTE IS A PRIME EXAMPLE OF KAHN'S CONCENTRA-
TION ON THE FUNCTION OF THE DESIGN. THE USE OF A TROUGH WAS A
REVOLUTIONARY MOVE FOR THE OUTHOUSE; IT COULD ACCOMMODATE
MULTIPLE USERS AT ONE TIME. HIS DESIGN ALSO TOOK THE "OUT" CON-
CEPT TO THE EXTREME BY PROVIDING NO ENCLOSURE. ALTHOUGH IT IS
CONSIDERED SUCCESSFUL BY MANY THE DESIGN HAS NOT BECOME POP-
ULAR. THE PRIMARY CRITICISM IS THAT IT ONLY CATERS TO MALES AND
CANNOT BE USED FOR ALL ACTIVITIES.

**OUTHOUSES
BY FAMOUS ARCHITECTS**

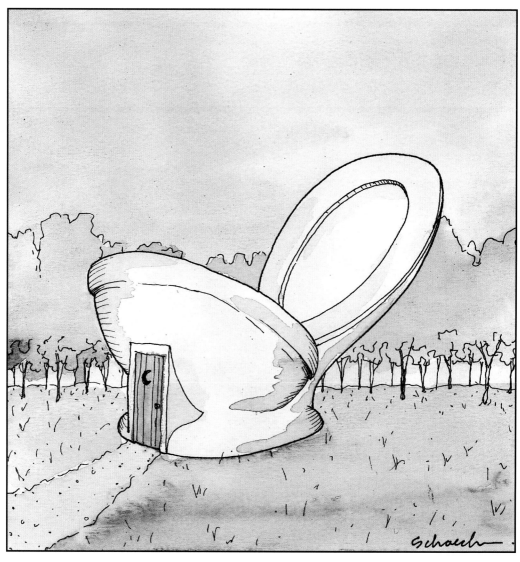

OUTDOOR MANURE TERMINAL

EERO SAARINEN

BORN 1910, KIRKKONUMMI, FINLAND
DIED 1961, ANN ARBOR, MICHIGAN

EERO SAARINEN WAS THE SON OF THE NOTABLE ARCHITECT ELIEL SAARINEN. HE WENT TO SCHOOL IN PARIS AND AT YALE UNIVERSITY, AND WORKED WITH HIS FATHER FOR SEVERAL YEARS BEFORE STARTING HIS OWN PRACTICE. SAARINEN INITIALLY PURSUED SCULPTURE, BUT TURNED TO ARCHITECTURE AFTER A YEAR IN SCHOOL; STILL, HIS APPRE-CIATION FOR SCULPTURE CAN BE SEEN IN HIS DESIGN APPROACH.

LABELED A NEO-EXPRESSIONIST, SAARINEN DEMONSTRATED AN ABILITY TO MOVE EASILY BETWEEN THE INTERNATIONAL STYLE AND EXPRESSIONISM. HIS MOST NOTED WORKS ARE VISUAL REPRESENTA-TIONS OF THE BUILDINGS' FUNCTIONS. HE DESIGNED THE TWA TERMINAL AT JFK AIRPORT TO CONJURE IMAGES OF A PREHISTORIC BIRD PREPARING TO FLY. HIS BUILDINGS UTILIZE FREE-FLOWING CURVES, SCULPTED FROM DIFFERENT MATERIALS TO CREATE STRIKING MASSES THAT COMPLEMENT THE BUILDINGS' FUNCTION.

SAARINEN'S OUTDOOR MANURE TERMINAL EXPRESSES ITS FUNC-TION IN HIS TYPICAL ELOQUENT STYLE. THE "SOARING TOILET" (AS IT IS CALLED BY LOCAL USERS) IS IMMEDIATELY IDENTIFIABLE AS THE "PLACE WHERE SHIT FLIES." IT IS A SINGLE MASS CARVED TO BE A SIMPLE ICON FOR THE COMMUNITY. SAARINEN COMMENTED THAT HE WAS TRYING TO CREATE A FEELING OF LIGHTENING WITH THIS FACILITY. ITS SLEEK AND EFFICIENT DESIGN IS BREATHTAKING—AND PROFOUNDLY APPRECIATED BY ITS USERS.

OUTHOUSES BY FAMOUS ARCHITECTS

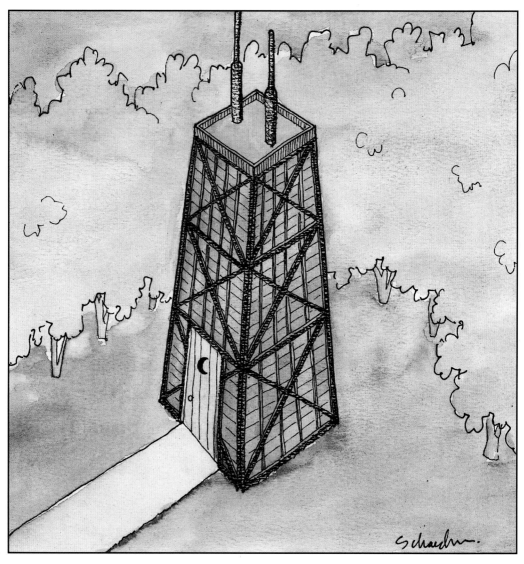

THE HANCOCK'S JOHN BUILDING

BRUCE GRAHAM/SOM

BORN 1925, BOGOTA, COLOMBIA

Bruce Graham graduated in 1948 from the University of Pennsylvania with a degree in architecture. He worked briefly for Holabird and Roche, went on to become chief of design for the firm of Skidmore, Owings and Merrill, and was named a general partner in 1960.

One of the leading American designers of the skyscraper, Graham was a major proponent of Miesian principles in his designs and helped to establish the acceptance of the Van der Rohe style. Surprisingly, he never actually studied under Mies. In the late sixties and early seventies, Graham developed several towers that utilized a revolutionary tubular frame. These towers are overpowering monuments to the continuing advances of technology and corporate America.

Graham's most notable structure is the John Hancock Center in Chicago. The Hancocks loved the design so much, they asked him to recreate the design in an outhouse. The identifying diagonal x-bracing tubes let the outhouse reach heights never before achieved in this type of building. The height also provides an overpowering proportion that makes the individual user of the facility feel insignificant—enough so that users are prompt with their business. This factor has made this outhouse one of the most efficient of its time.

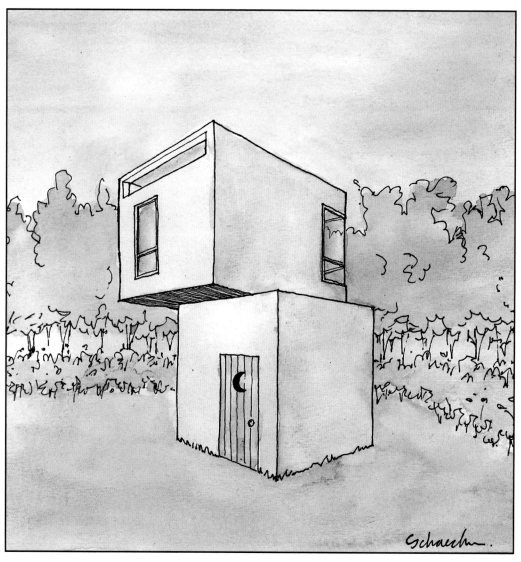

HADTOSHAT '67

MOSHE SAFDIE

BORN 1938, HAIFA

MOSHE SAFDIE STUDIED AT MCGILL UNIVERSITY IN MONTREAL FROM 1955 TO 1961. HE WORKED IN LOUIS KAHN'S OFFICE FOR TWO YEARS, AND THEN STARTED HIS OWN PRACTICE IN MONTREAL. HE LATER MOVED TO THE UNITED STATES, ESTABLISHED AN OFFICE, AND TAUGHT AT HARVARD UNIVERSITY.

SAFDIE IS BEST KNOWN FOR HIS REVOLUTIONARY DESIGN FOR A COMPARTMENTALIZED RESIDENTIAL FACILITY FOR THE MONTREAL EXPOSITION OF 1967—HABITAT. AN EXTENSION OF SAFDIE'S THESIS IN SCHOOL, THE DESIGN DISREGARDED THE PREDISPOSITION OF STYLE AND FOCUSED ON THE FACILITY'S UTILITARIAN ASPECT. THIS SYSTEM WAS BASED ON PREFABRICATED MODULES STACKED AROUND UTILITY CORES, AND ITS OVERALL APPEARANCE IS REMINISCENT OF A STACK OF BUILD-ING BLOCKS. THE SYSTEM HAS BEEN IMPLEMENTED AND REFINED IN OTHER AREAS OF THE WORLD.

AS PART OF HIS THESIS, SAFDIE PRODUCED A MOCK-UP FOR HIS FACILITY. CONSTRUCTED IN HIS BACK YARD, THE MOCK-UP WAS GIVEN THE FUNCTION OF AN OUTHOUSE. PREFABRICATION OF THE PARTS WAS NOT CHARACTERISTICALLY ECONOMICAL IN THIS SITUATION DUE TO THE LIMITED NUMBER OF MODULES REQUIRED. SAFDIE FOUND THROUGH STUDY OF HIS MOCK-UP THAT THE CONFIGURATION OF THE CUBES GREATLY AFFECTS AIR QUALITY WITHIN THE SPACE. AN OVERHEAD AIR CHAMBER INCLUDED IN HIS HABITAT 67 ALLOWED THE USER TO BREATHE COMFORTABLY.

OUTHOUSES BY FAMOUS ARCHITECTS

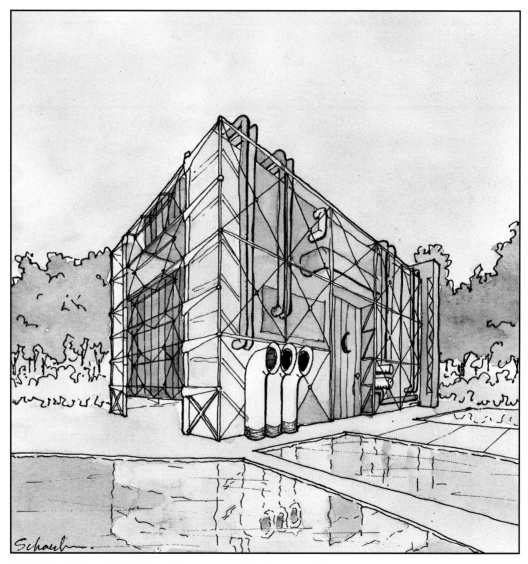

THE CENTRE POMPIDOODOO

ROGERS AND PIANO

RICHARD ROGERS, BORN 1933, FLORENCE
RENZO PIANO, BORN 1937, GENOA

RICHARD ROGERS STUDIED AT THE ARCHITECTURAL ASSOCIATION SCHOOL IN LONDON. HE WORKED IN PARTNERSHIP WITH NORMAN FOSTER AS "TEAM 4." RENZO PIANO STUDIED AT THE MILAN POLYTECNICO, WHERE HE ALSO TAUGHT UNTIL 1968. IN 1970 ROGERS AND PIANO ESTABLISHED A PARTNERSHIP.

ROGERS' AND PIANO'S WORK REJECTED THE CLASSICAL PAST AND ENTHUSIASTICALLY EMBRACED THE "HIGH-TECH." THEY DEVELOPED AN AESTHETIC APPROACH THAT ALLOWED THE TECHNOLOGY TO DRIVE THE DESIGN. BUILDINGS' SYSTEMS ARE COLOR CODED AND EXPOSED TO CREATE A MACHINELIKE APPEARANCE, EXTERNALLY AND INTERNALLY. THE ARCHITECTURE IS REDUCED TO A BACKDROP FOR THE SERVICES. THE PARTNERSHIP HAS BEEN DISSOLVED BUT BOTH ARCHITECTS ARE STILL INFLUENCED BY THE APPROACH THEY DEVELOPED TOGETHER.

THE CENTRE POMPIDOODOO ILLUSTRATES THEIR DESIGN APPROACH. EXHAUST VENTS AND STRUCTURE ARE DISPLAYED ON THE EXTERIOR OF THE BUILDING IN BRIGHT COLORS. THE HIGH-TECH APPROACH HAS BEEN CRITICIZED FOR ITS APPLICATION IN THIS FACILITY. PEOPLE ARE FORCED TO ACCEPT THEIR ROLES IN THE FUNCTION OF THE MACHINE. THE USE OF CLEAR TUBES FOR THE WASTE MANAGEMENT SYSTEM APPEARS TO DISCOURAGE MANY POTENTIAL USERS. STILL, THE DESIGN DOES INFLUENCE THE USER TO BECOME MORE CONSCIOUS OF WHAT IS ACTUALLY REQUIRED TO FACILITATE HIS OR HER NEEDS. IT IS A TRUE EDUCATIONAL TOOL.

OUTHOUSES BY FAMOUS ARCHITECTS

BIBLIOGRAPHY

THE COLUMBIA ENCYCLOPEDIA, 5TH ED. (COLUMBIA UNIVERSITY PRESS, 1993).

EMMANUEL, M., CONTEMPORARY ARCHITECTS (ST. MARTIN PRESS, 1980).

FRAMPTON, K., MODERN ARCHITECTURE: A CRITICAL HISTORY (THAMES AND HUDSON, 1980, 1985).

MITCHELL, J., "THE CELTIC DRUIDS," BRITANNIA INTERNET MAGAZINE (1996, 1997, 1998).

PLACZEK, A., MACMILLAN ENCYCLOPEDIA OF ARCHITECTURE, VOLS. 1–2 (THE FREE PRESS, 1982).

RAEBURN, ARCHITECTURE OF THE WESTERN WORLD (ORBIS PUBLISHING LIMITED, 1980).

SHARP, D., THE ILLUSTRATED ENCYCLOPEDIA OF ARCHITECTS AND ARCHITECTURE (QUATRO PUBLISHING, 1991).

TRACHTENBURG AND HYMAN, ARCHITECTURE: FROM PREHISTORY TO POST-MODERNISM (HARRY N. ABRAMS B.V., 1986).

WHIFFEN AND KOEPER, AMERICAN ARCHITECTURE 1860–1976 (MASSACHUSETTS INSTITUTE OF TECHNOLOGY, 1981).

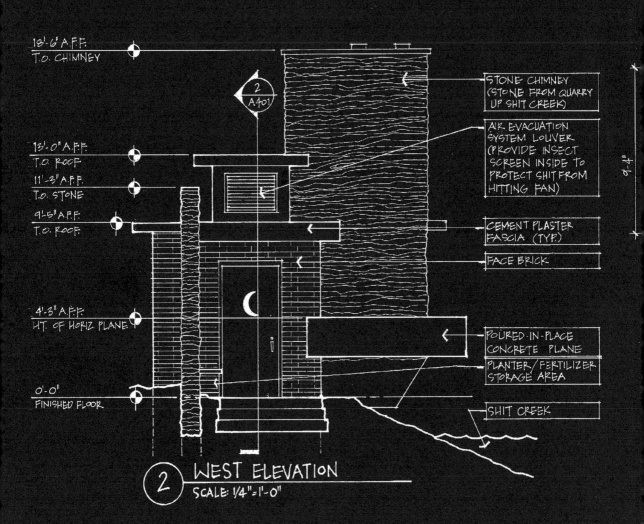

18'-6" A.F.F.
T.O. CHIMNEY

13'-0" A.F.F.
T.O. ROOF

11'-3" A.F.F.
T.O. STONE

9'-5" A.F.F.
T.O. ROOF

4'-3" A.F.F.
HT. OF HORIZ PLANE

0'-0"
FINISHED FLOOR

2
A401

9'-4"

STONE CHIMNEY
(STONE FROM QUARRY
UP SHIT CREEK)

AIR EVACUATION
SYSTEM LOUVER
(PROVIDE INSECT
SCREEN INSIDE TO
PROTECT SHIT FROM
HITTING FAN)

CEMENT PLASTER
FASCIA (TYP.)

FACE BRICK

POURED-IN-PLACE
CONCRETE PLANE

PLANTER/FERTILIZER
STORAGE AREA

SHIT CREEK

2 WEST ELEVATION
SCALE: 1/4"=1'-0"